MILLE FIORI

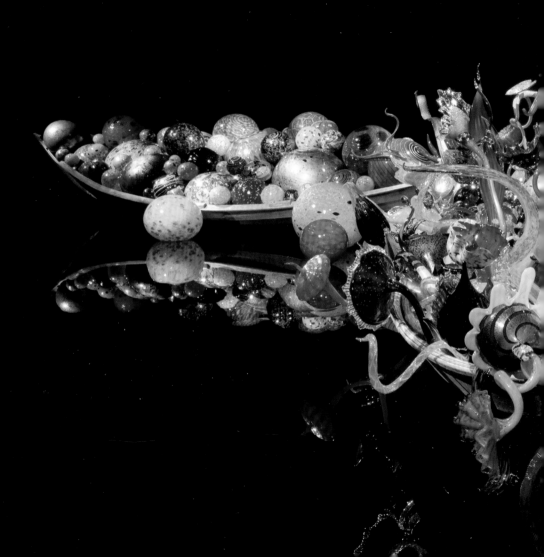

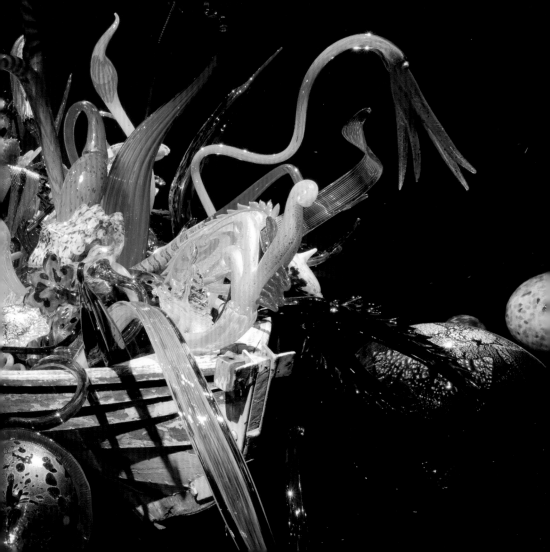

CHIHULY'S *FIORI*: MAGICAL GARDENS

DALE CHIHULY'S SERIES GENERALLY DEVELOP OVER SEVERAL DECADES. The *Fiori* is one of his more recent series, with its official beginning in 2003. Its vocabulary and concept, however, have roots deep in Chihuly's past and, as in much of his work, offer illuminating insights into the artist's long-standing creativity, his ability to bring out the best in others, and his own persona.

Inspired by childhood events, the *Fiori* (the Italian word for "flowers") embodies Chihuly's lifelong passion for nature and flowers, which he attributes to his mother. As a young child, Chihuly spent much of his time with his mother, since jobs frequently took his father away; moreover, his father died when Chihuly was still a teenager. Some of his fondest memories center on his mother's bountiful year-round blooming garden surrounding their modest Tacoma home. The name *Fiori* also reflects his own passion for anything Italian, which began with his first trip to Venice, in 1968, and was fueled by friendships with artists and colleagues from Italy.

The initial *Mille Fiori* was created for the 2003 opening of the Tacoma Art Museum's new building. The most monumental of all the *Mille Fiori* sculptures to date, it consisted

Preceding page:
Float Boat and
Ikebana Boat

de Young Museum
San Francisco, California
2008

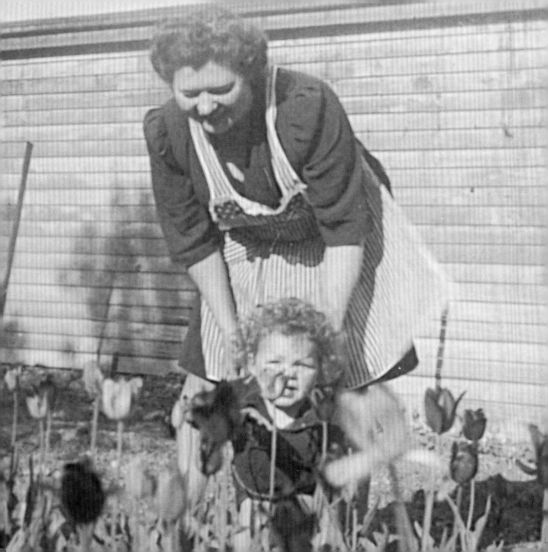

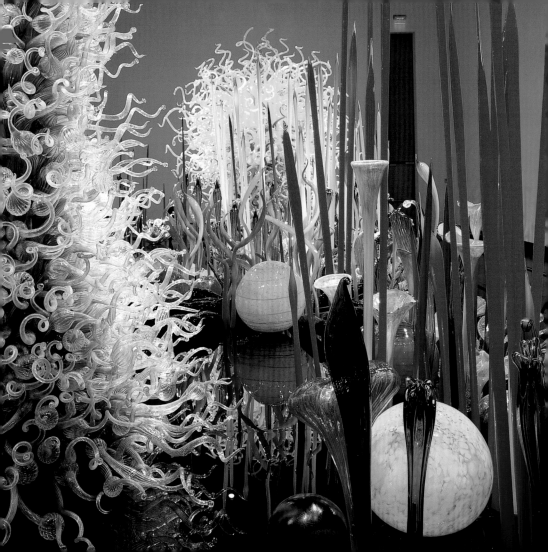

Mille Fiori

Tacoma Art Museum
Tacoma, Washington
2003, 25 x 28 x 56'

of a densely packed, wide variety of Chihuly's brilliantly colored, flora-like forms, including *Reeds*, *Fiddleheads*, *Seal Pups*, and *Herons*, juxtaposed with earlier series such as *Towers*, *Persians*, and numerous *Floats* on a low, 1,500-square-foot platform. It directly resulted from Chihuly's first major glasshouse exhibition, at Chicago's Garfield Park Conservatory in 2001–2, where he experienced firsthand the affinity between his own aesthetic and nature. A blown-glass garden was a logical outgrowth of his childhood familiarity and seeing his art in a botanical setting.

The overwhelmingly positive response to the first *Mille Fiori* inspired the *Fiori* series, which continues today. Although the artist has installed floral forms in natural settings since the early 1970s, the Chihuly Studio points out that not all of these installations are *Fiori*. The studio defines the *Fiori* as primarily post-2003 clusters of different plantlike forms, including *Pods*, that are assembled on small, standardized bases like window boxes or as orchestrated gardens on platforms ranging up to fifty-six feet in length. The latter generally are called *Mille Fiori*—a play on the word "millefiori" (Italian for "one thousand flowers"),

a term that describes the process of fabricating objects from preformed, stacked, and then crosscut, multicolored glass rods, which are fused in a mold. Since 1995, these floral elements have also been placed in natural outdoor settings as well as in public gardens and glasshouses, as part of the "intervention" exhibitions that Chihuly has done at the New York Botanical Garden, St. Louis's Missouri Botanical Garden, and in numerous other American cities and at the Royal Botanic Gardens, Kew, England.

The varieties of flora-like forms used in the *Fiori* and the outdoor garden exhibitions fluctuate from a select few to a dense multitude. The earliest *Mille Fiori* are perhaps the most packed; the plinth pieces feature only a few. Since 2004, Chihuly has been exploring more minimal groupings on medium-sized platforms. These investigations led to his most recent monumental statement, at the Venice Biennale in 2009, where eight varieties of forms are sparsely positioned around a central *Tower*. Over the years, *Fiori* and *Mille Fiori* palettes have varied from multicolored to more limited, particularly in 2004 and 2005. Dramatic color combinations mark the more recent *Mille Fiori*. As in the

Mille Fiori Venezia

Venice Biennale
Venice, Italy
2009, 9½ x 56 x 12'

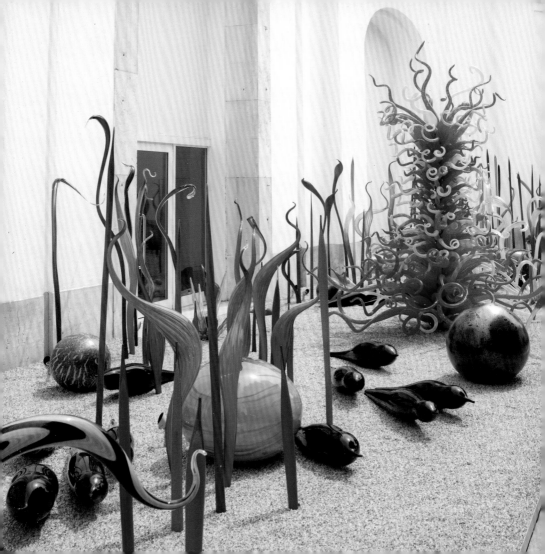

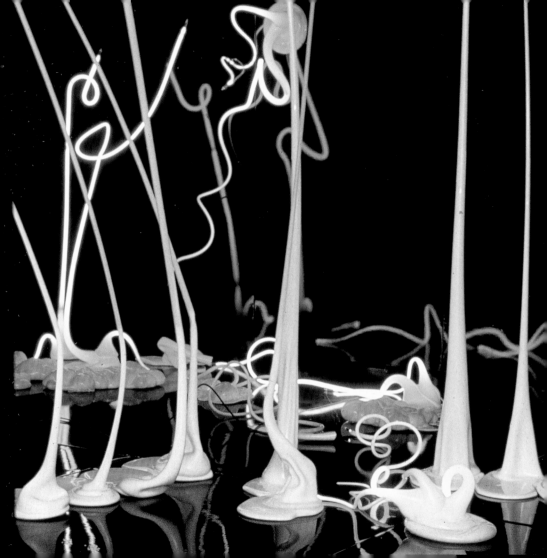

Putti and the *Persians*, which Chihuly sees as adaptations of historical decorative arts, the artist is emphatic that he is not copying nature or gardens but interpreting them, in both form and content.

Chihuly purposefully has drawn from all parts of his career in the series, coming full circle. In addition to subject matter, the massing of the forms—particularly the tense juxtaposition of vertical and horizontal elements and their placement on Plexiglas in carefully designed spaces—is reminiscent of the 1971–72 traveling installation *Glass Forest*, which Chihuly and James Carpenter initially created for the Museum of Contemporary Crafts, New York (now the Museum of Arts and Design). Chihuly's actual floral compositions date from the 1980s, first with the 1985–86 *Flower Forms*, and after 1988 with the *Venetians* and the *Ikebana*.

While the *Fiori Pods* evoke the 1970 Carpenter/Chihuly installation at Haystack Mountain School of Crafts, Deer Isle, Maine, plantlike forms such as the *Reeds*, *Belugas*, *Herons*, *Trumpets*, *Seal Pups*, *Fiddleheads*, *Split Horns*, and *Saguaros* are the products of the 1995–96 *Chihuly Over Venice* project. As part of that project, the artist had Martin

Glass Forest #1

In collaboration
with James Carpenter
Museum of Contemporary
Crafts, New York
1971, 500 sq. ft.

Blank, a lead gaffer from Team Chihuly, create forms in less than four minutes without any reheating or reworking at the Nuutajärvi, Finland, and Waterford, Ireland, factories; the artworks were then immediately integrated into outdoor settings.

Since 2003, there has been an explosion of new *Fiori* elements, which have been created primarily by lead gaffer Joey DeCamp, with some of the most intense activity surrounding the 2004 show at the Marlborough gallery, New York. Most *Fiori* elements are either variations on long tendrils of pulled glass or irregularly shaped, elongated blown forms.

As part of Chihuly's desire to have the *Fiori* revisit "techniques we've learned over the last thirty-five, forty years," one of his most dramatic series, the *Floats*, has been incorporated in new ways. As blown spheres, they are the simplest forms to make in glass; however, they push glass-blowing to its limits due to their extreme size and weight, requiring large teams and special equipment. As a stand-alone series begun in 1991, the *Floats* were the result of trips Chihuly made to the tiny island of Niijima in Japan's

Chihuly and hotshop team

The Boathouse hotshop
Seattle, Washington, 1992

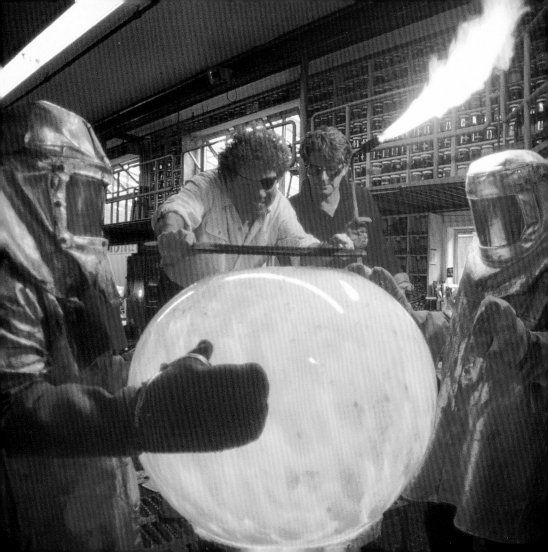

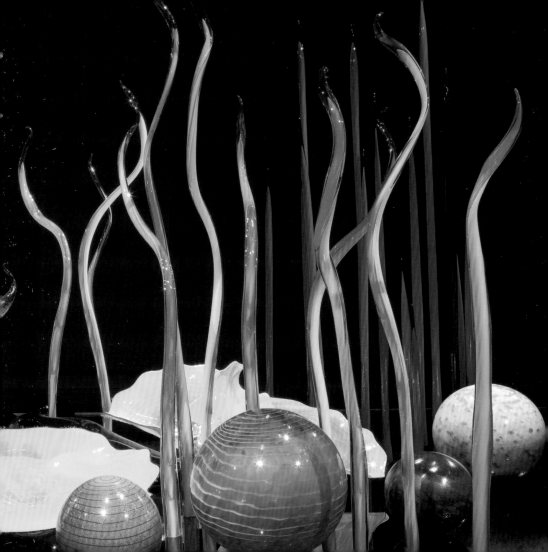

Tokyo Bay, in 1988 and again in 1990, where he was reminded of the fishing floats of his youth. For many years, they were primarily installed individually, on beds of crushed glass or in clusters on the ground or in water, echoing the repeated components of Minimal Art. They also formed part of the assemblages that constitute the *Chandeliers*, *Towers*, and *Boats*. Since 2003–4, multiple isolated *Floats* have joined other small, colorful elements such as *Green Grass*, *Seal Pups*, and *Pods* on the huge platforms of the *Mille Fiori*, to provide strong horizontal thrusts that counterbalance the vertical flora-like elements; in the smaller sculptures, they frequently provide the primary horizontal accent within otherwise vertically oriented compositions.

Davira S. Taragin
Former Director of Exhibitions and Programs,
Racine Art Museum;
former Curator, The Detroit Institute of Arts,
Toledo Museum of Art

Mille Fiori

Columbus Museum of Art
Columbus, Ohio
2009, 9 x 25½ x 10'

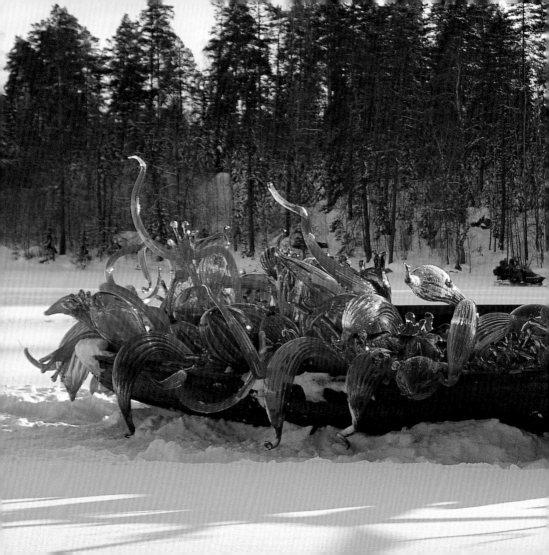

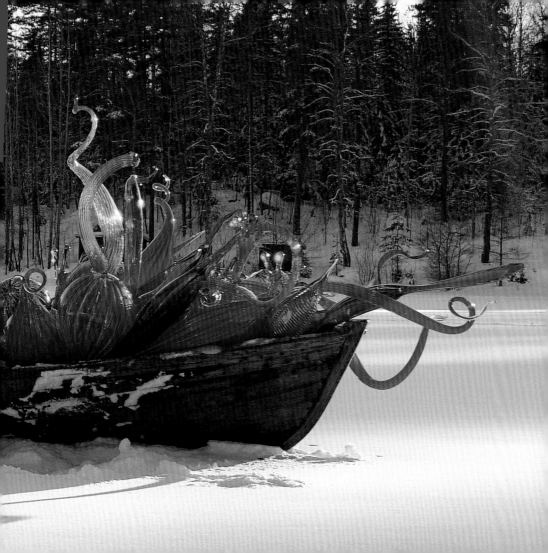

Red Finnish Boat (detail)

Nuutajärvi, Finland
2002, 19 x 8'

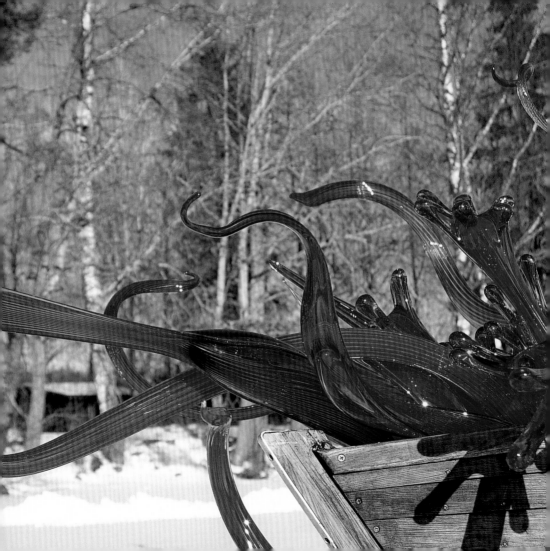

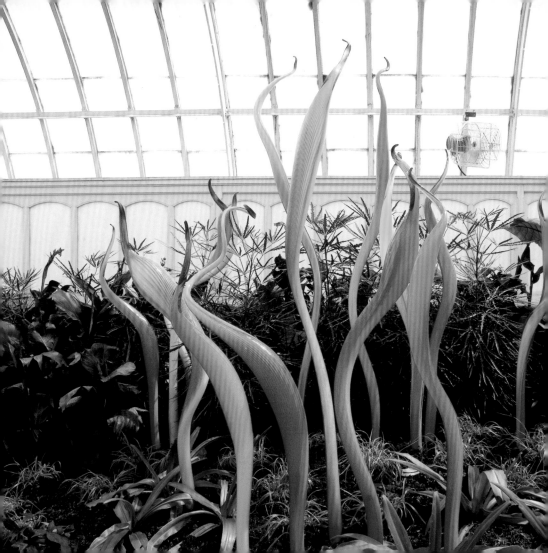

Amber Cattails

Phipps Conservatory and Botanical Gardens
Pittsburgh, Pennsylvania, 2007

Following page:
Nova Southeastern University Fiori

Nova Southeastern University
Fort Lauderdale–Davie, Florida, 2007

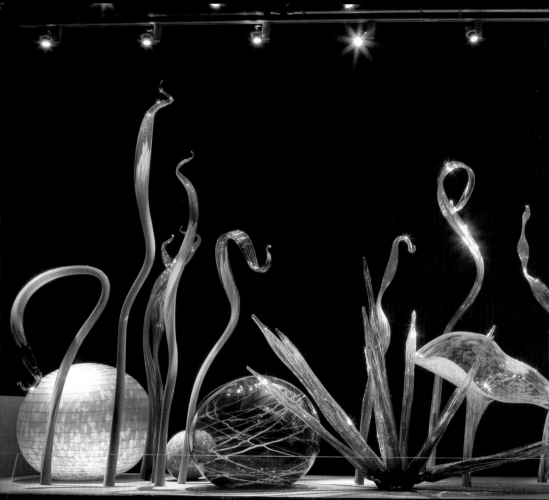

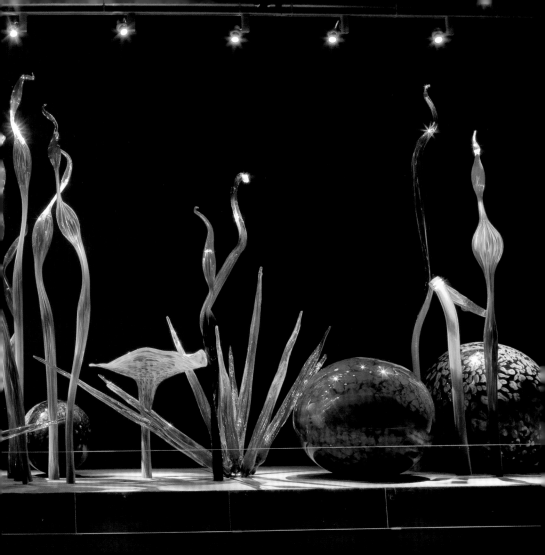

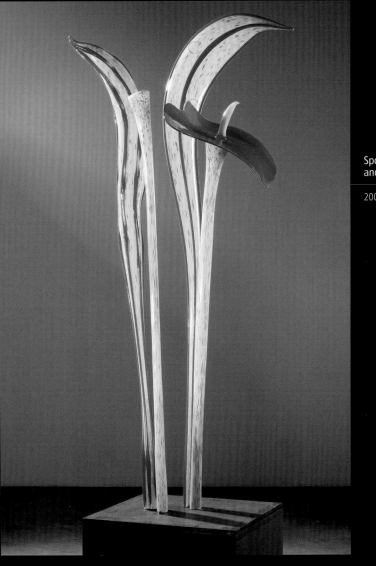

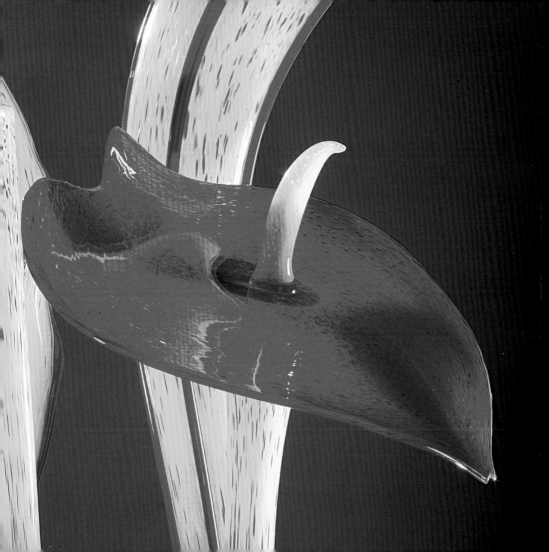

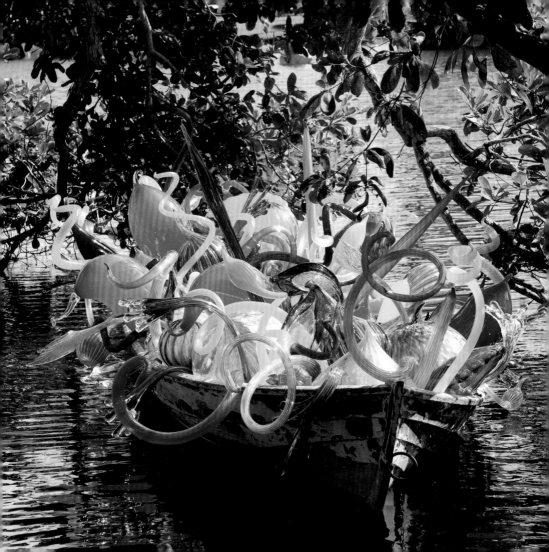

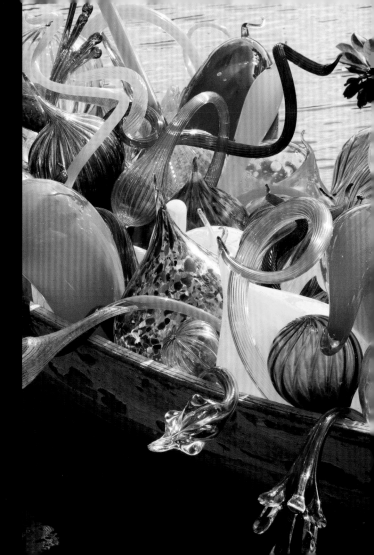

Carnival Boat

Fairchild Tropical
Botanic Garden
Coral Gables, Florida
2006, 6 x 19 x 7'

CHIHULY STUDIO 1111 NW 50TH STREET SEATTLE, WA 98107-5120
TEL: 206 781 8707 FAX: 206 781 1906

4 towers
lots of va
gardens

Tacoma Art Museum 10·29·02

Tacoma garden?

Blue

moon

citrus

maybe round bases for everything
drawings or photos on walls?!
10' of aisle all the way around

76'

56' × 28' ?

48'

vs glass
ween

036

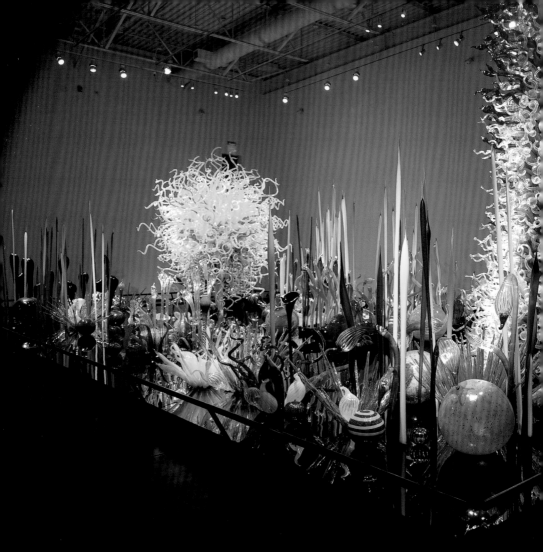

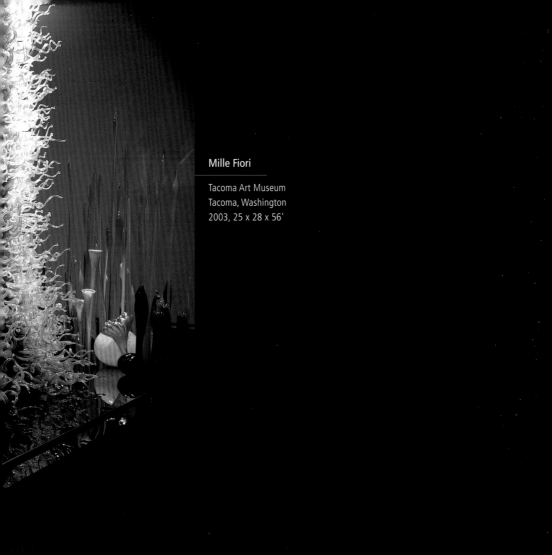

Mille Fiori

Tacoma Art Museum
Tacoma, Washington
2003, 25 x 28 x 56'

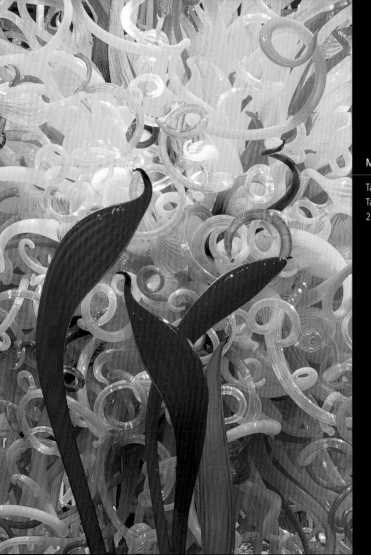

Mille Fiori (detail)

Tacoma Art Museum
Tacoma, Washington
2003, 25 x 28 x 56'

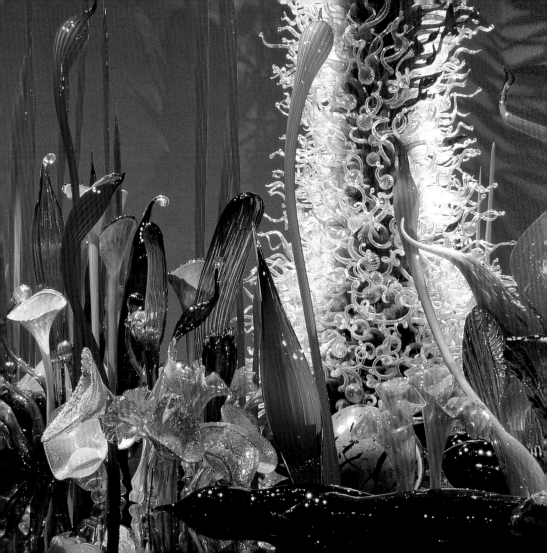

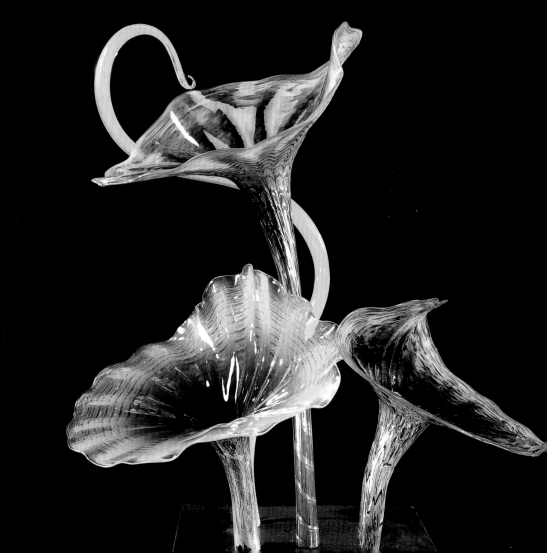

Golden Celadon
Fiori (detail)

2005, 45 x 36 x 29"

Mille Fiori Drawing

2004, 42 x 30"

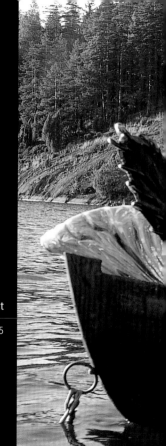

The Boat

Nuutajärvi, Finland, 1995

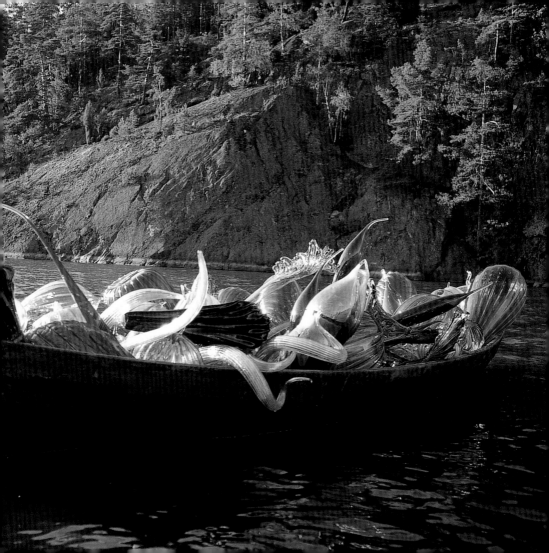

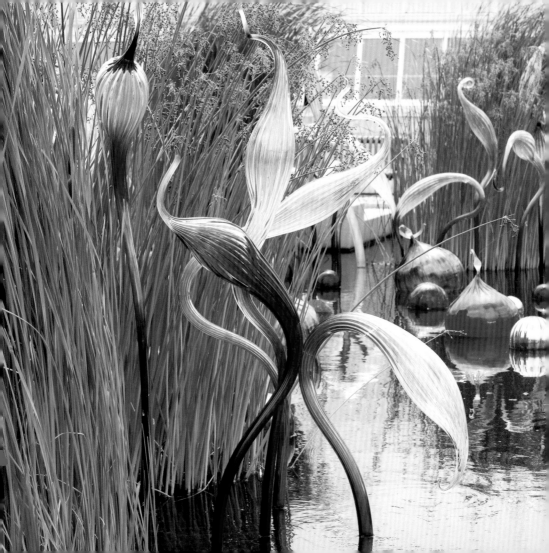

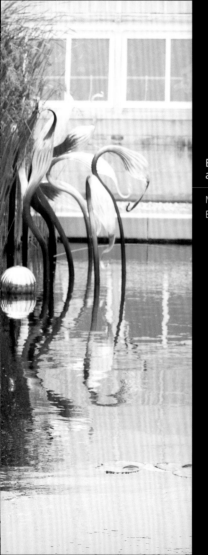

Blue Herons, Walla Wallas, and Reichenbach Mirrored Balls

New York Botanical Garden
Bronx, New York, 2006

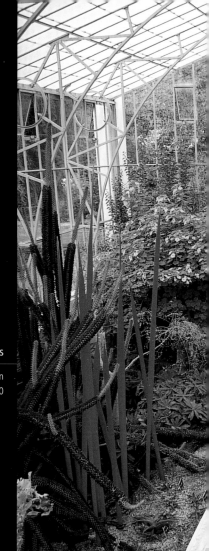

Red Reeds

Adelaide Botanic Garden
Adelaide, Australia, 2000

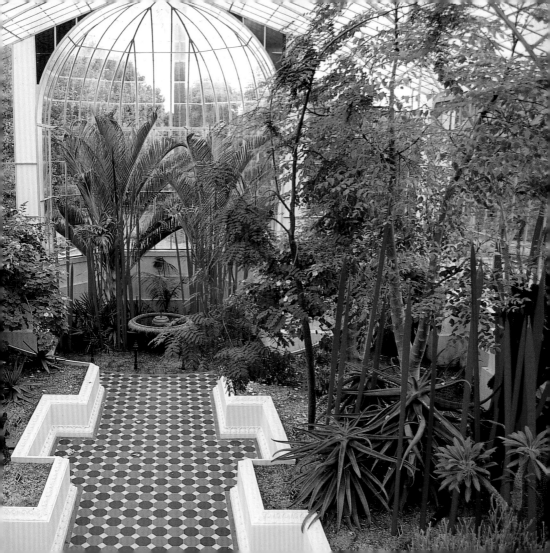

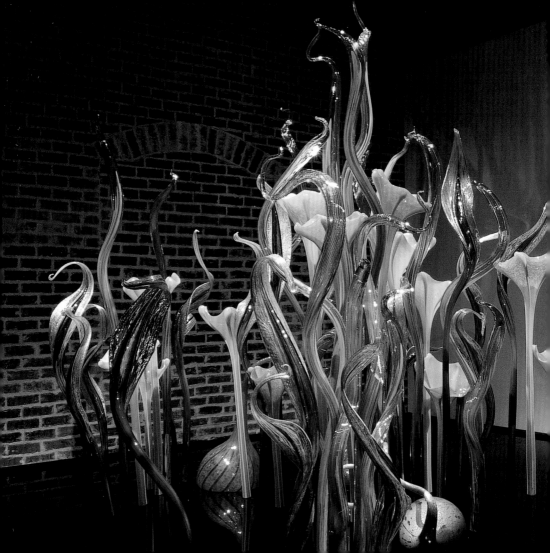

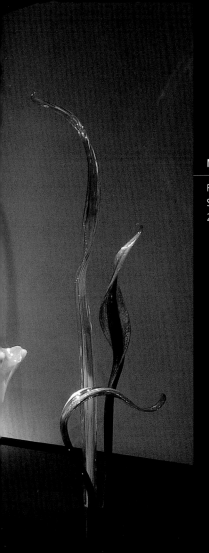

Mille Fiori V

Foster/White Gallery
Seattle, Washington
2004, 8 x 12 x 12'

"CHIHULY GARDEN" @ MARLBOROUGH GALLERY OR
"MILLE FIORI" @ MARLBOROUGH GALLERY

About a dozen installations on 24'x48' platform
on Black Plexiglass

Chihuly
1·2·04

24'

I like the name "MILLE FIORI" – maybe that's best.
what do you think Pierre?

Nº 004

Fax sketch
of Mille Fiori

2004

Mille Fiori IV (detail)

Marlborough gallery, New York
2004, 20 x 20'

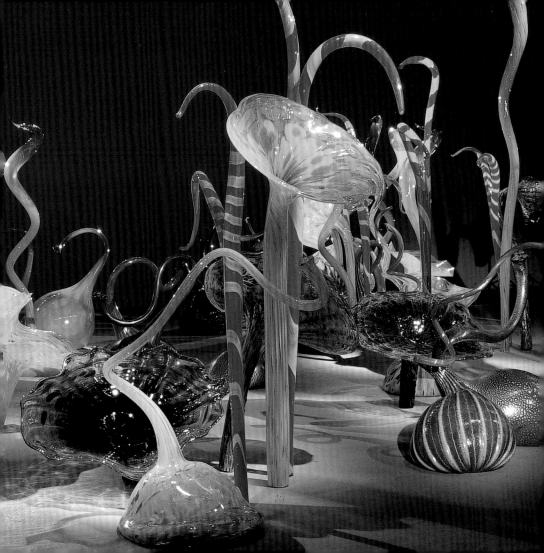

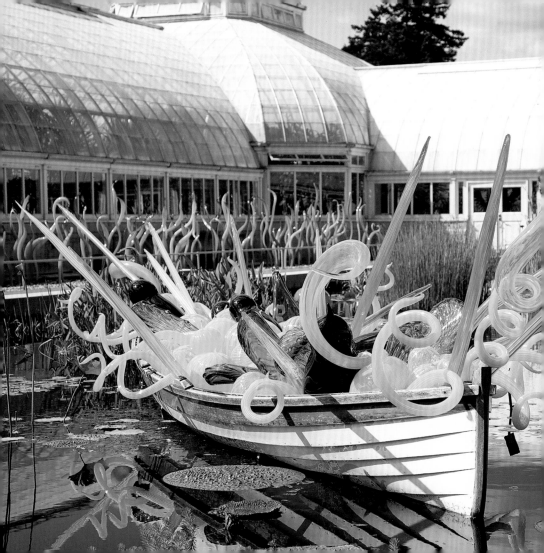

Yellow Boat

New York Botani
Bronx, New York
2006, 5 x 7 x 21

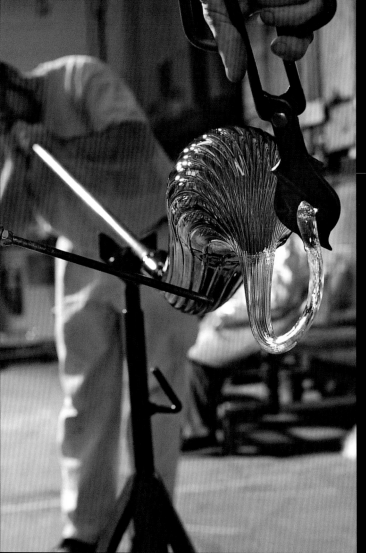

Heron in process

The Boathouse hotshop
Seattle, Washington

Optic Herons

Grounds For Sculpture
Hamilton, New Jersey
2002, 9 x 6'

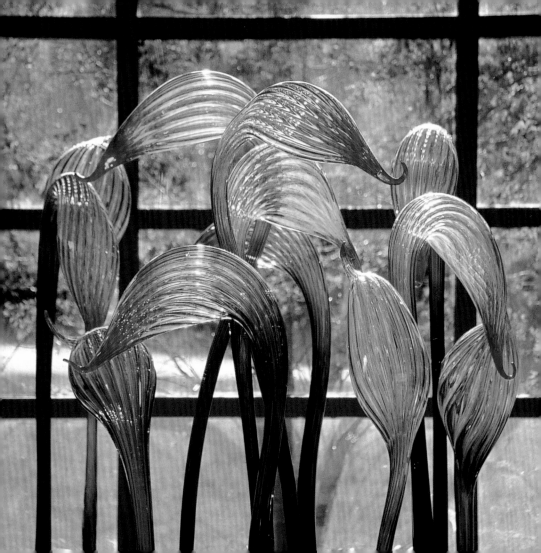

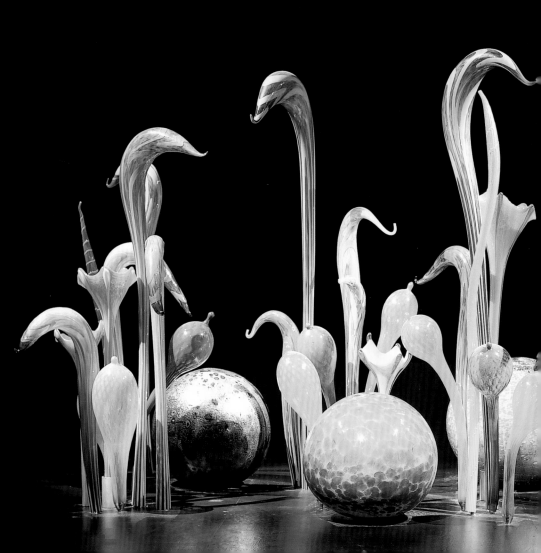

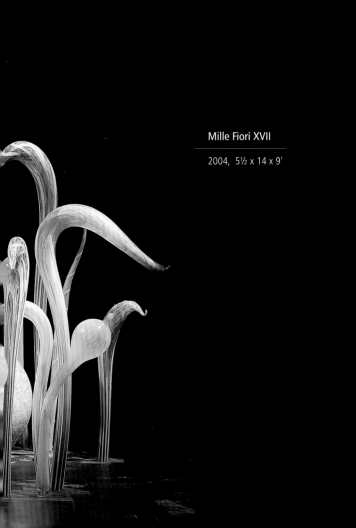

Mille Fiori XVII

2004, 5½ x 14 x 9'

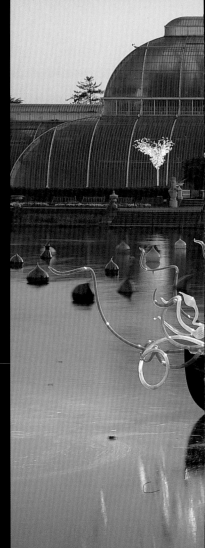

Thames Skiff

Royal Botanic Gardens, Kew
Richmond, England
2005, 6 x 28 x 8'

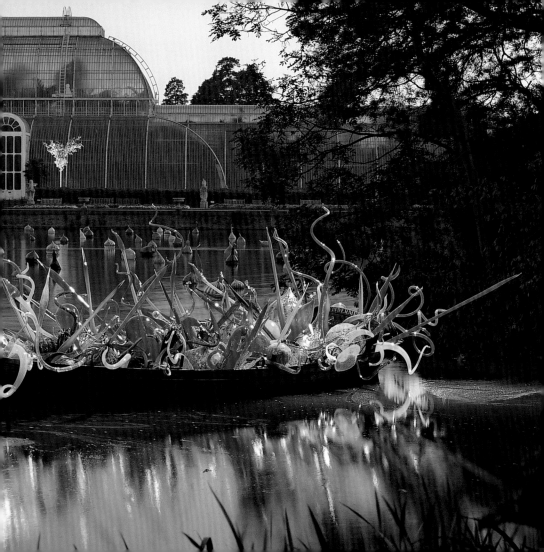

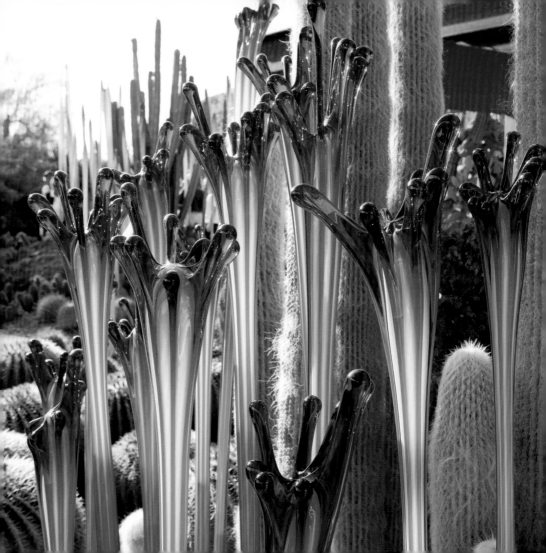

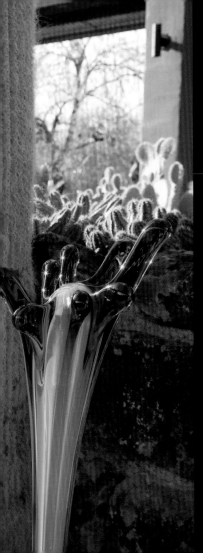

Blue Fiddleheads (detail)

Desert Botanical Garden
Phoenix, Arizona, 2008

Martin Blank and Michael Bray

Nuutajärvi Glass factory
Nuutajärvi, Finland, 1995

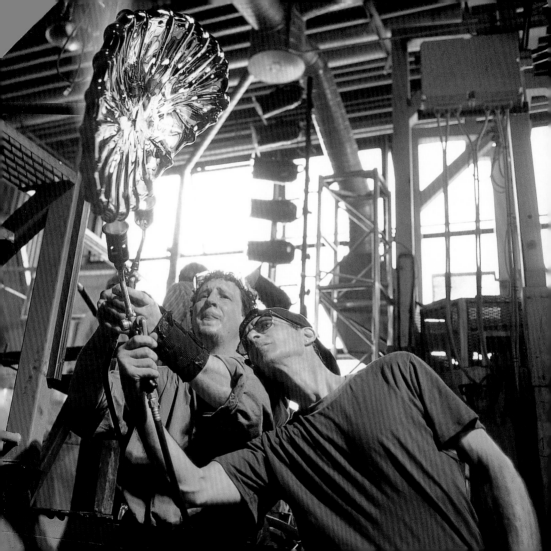

Mille Fiori Drawing

2004, 42 x 30"

Cobalt Marlins
and Trumpet
Flower Fiori

2009, 8 x 8 x 8'

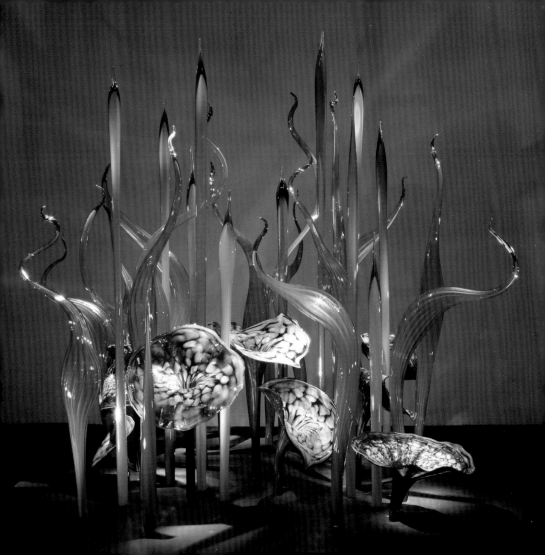

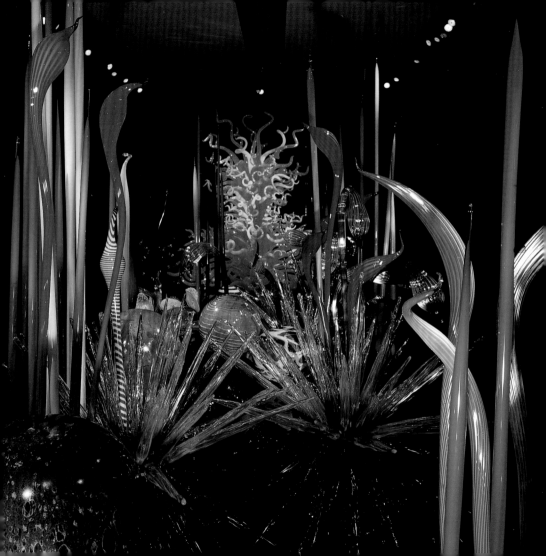

Lucerne Mille Fiori

Kunstmuseumluzern
Lucerne, Switzerland
2005, 10 x 32 x 10'

Following page:
Mille Fiori with Persian
Lilies and Eelgrass

2005, 5½ x 14½ x 6½'

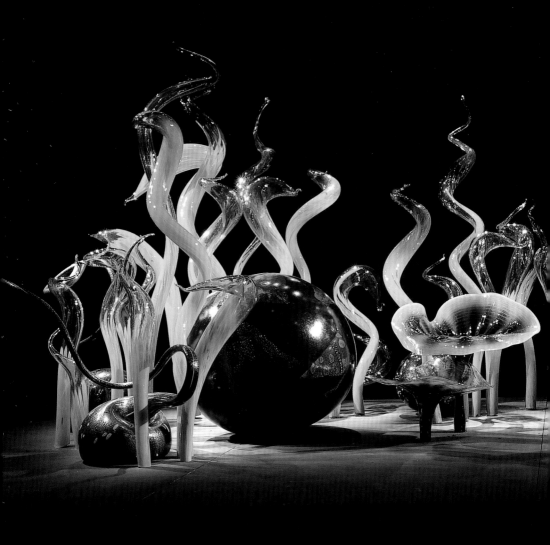

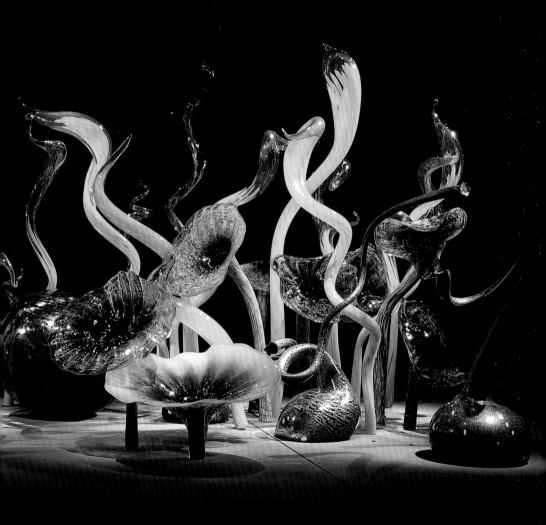

de Young Glass
Forest Drawing

2008, 30 x 22"

Glass Forest #3,
Revisited by the artist
based on Glass
Forest #1 and #2,
1971–72

In collaboration
with James Carpenter
de Young Museum
San Francisco, California

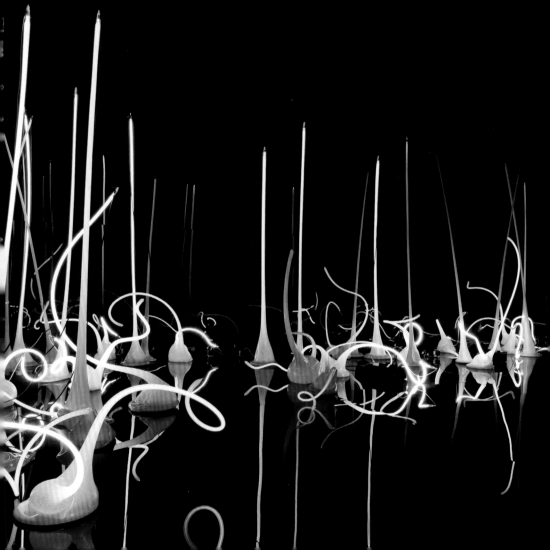

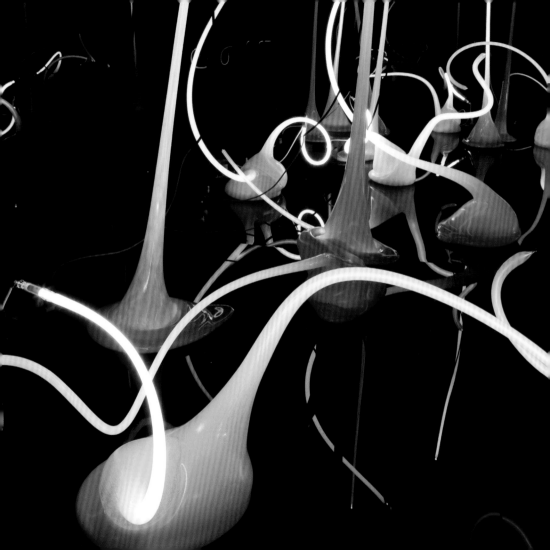

**Glass Forest #3 (detail),
Revisited by the artist
based on Glass Forest
#1 and #2, 1971–72**

In collaboration
with James Carpenter
de Young Museum
San Francisco, California
2008, 9 x 28 x 17'

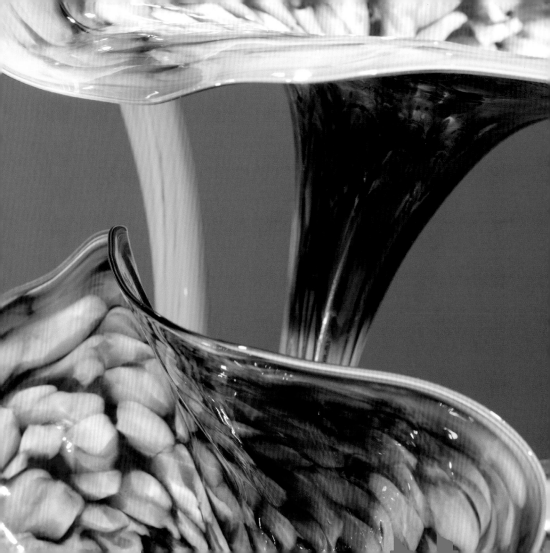

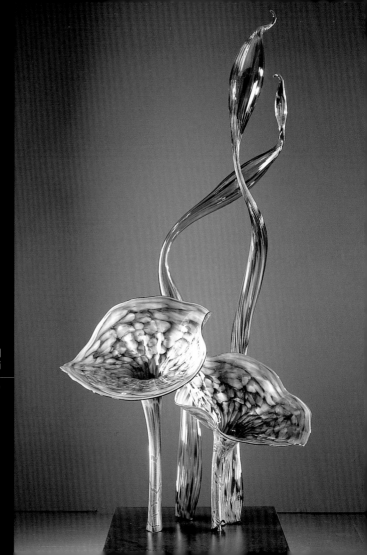

Violet and River Green
Dappled Fiori (detail)

2005, 54 x 34 x 32"

Dappled Violet and
Waterfall Green Fiori

2005, 67 x 33 x 27"

Sunset Boat

Chatsworth
Derbyshire, England
2006, 6½ x 23 x 9½'

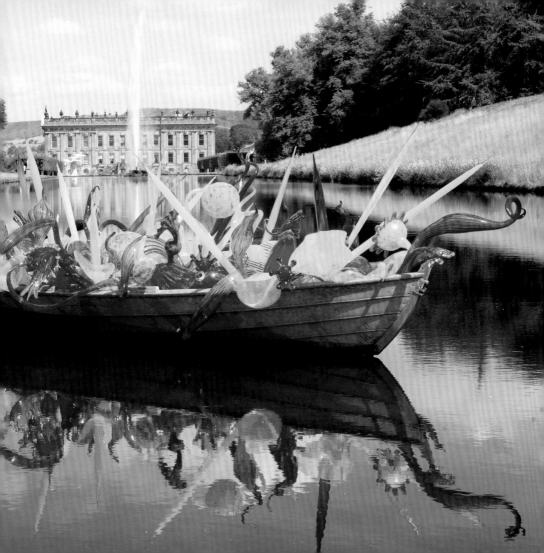

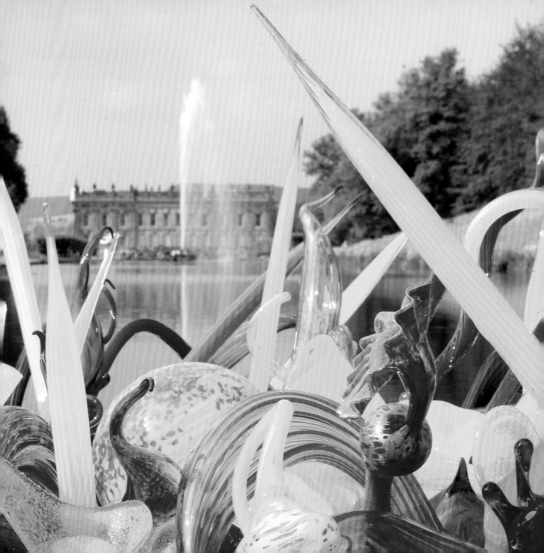

Sunset Boat (detail)

Chatsworth
Derbyshire, England
2006, 6½ x 23 x 9½'

Following page:
Boathouse Aquarium

The Boathouse
Seattle, Washington
2001, 4½ x 19 x 2½'

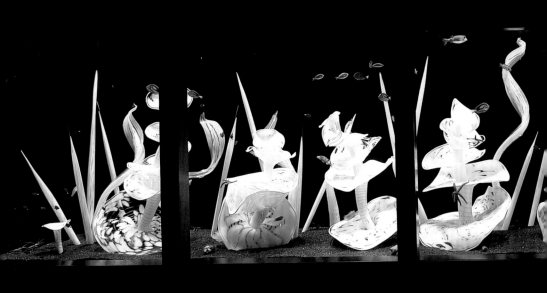

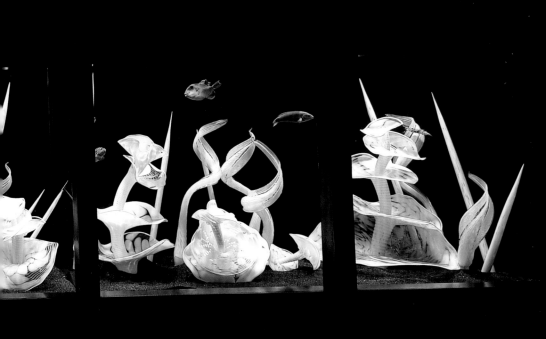

Boathouse Aquarium (detail)

The Boathouse
Seattle, Washington
2001, 4½ x 19 x 2½'

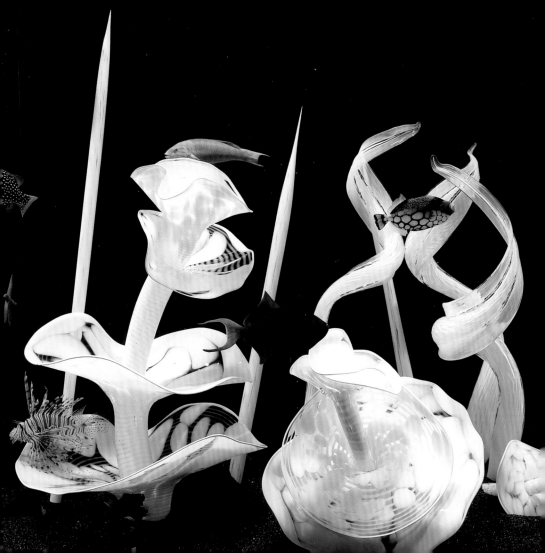

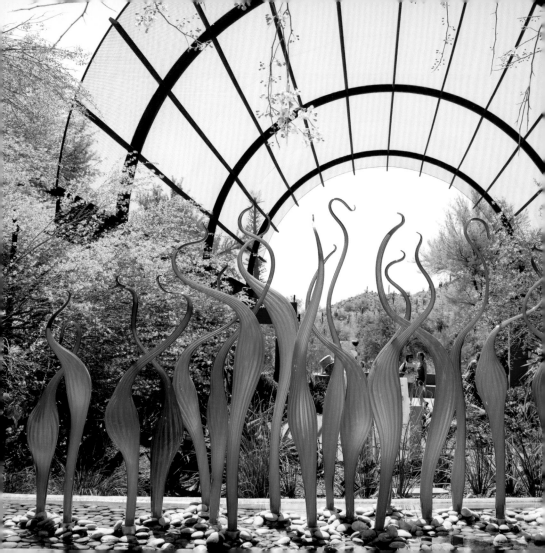

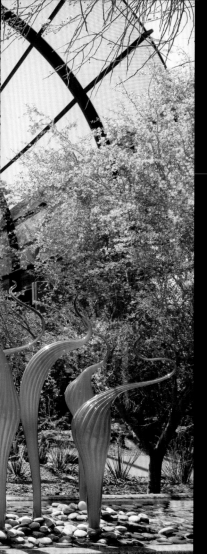

Blue Marlins

Desert Botanical Garden
Phoenix, Arizona
2008, 6 x 11 x 2½'

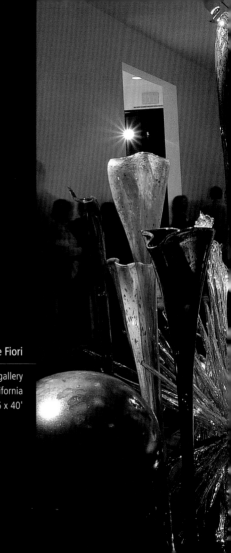

Mille Fiori

L.A. Louver gallery
Venice, California
2004, 9 x 16 x 40'

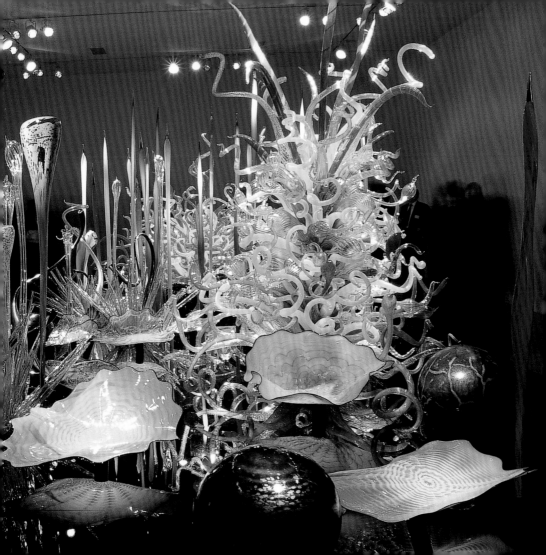

Joseph DeCamp and
Patricia Davidson with team

Museum of Glass
Tacoma, Washington, 2006

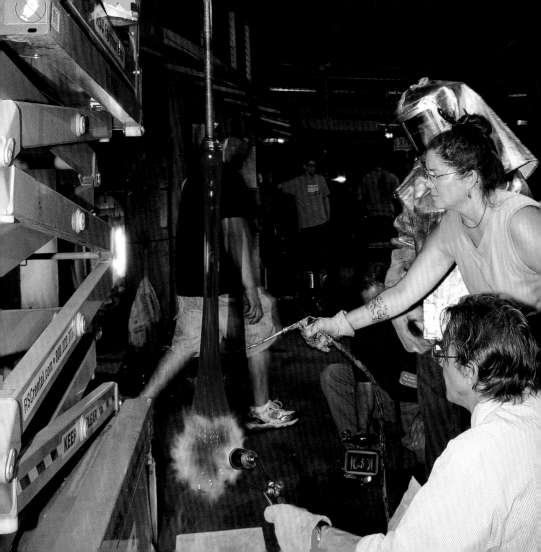

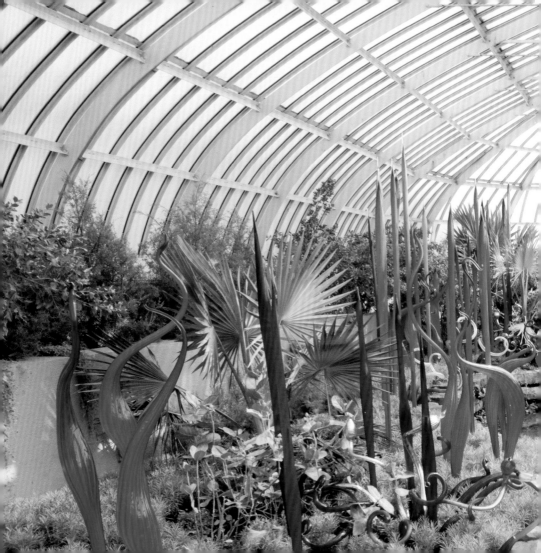

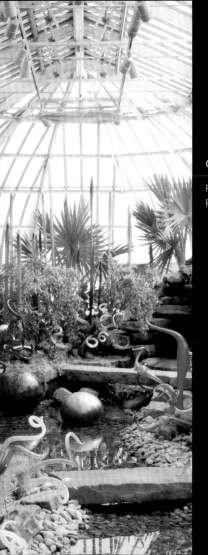

Cobalt Fiori

Phipps Conservatory and Botan[...]
Pittsburgh, Pennsylvania, 2007

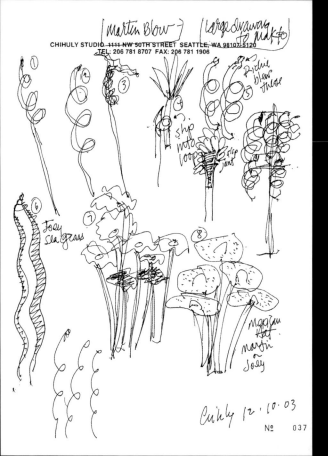

Fax sketch
of Fiori

2003

Iris Fountain
Yellow Herons

Phipps Conservatory
and Botanical Gardens
Pittsburgh, Pennsylvania
2007, 7 x 5 x 4'

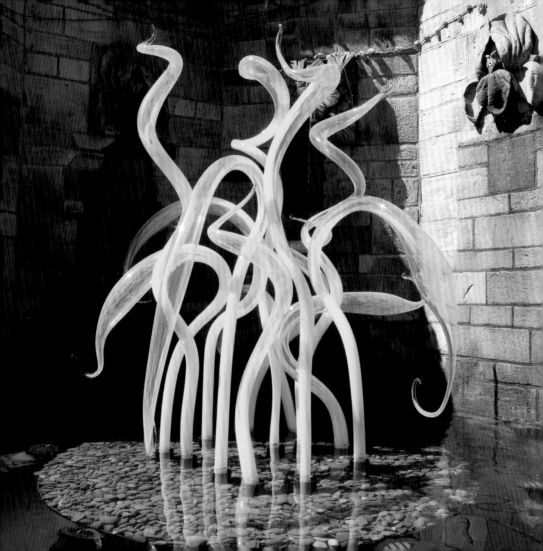

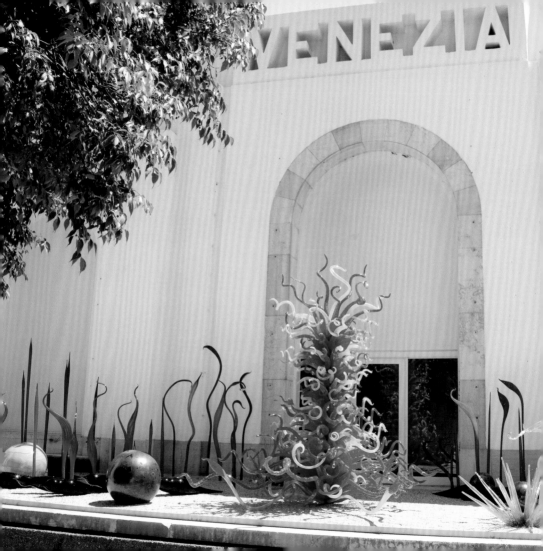

Mille Fiori Venezia

Venice Biennale
Venice, Italy
2009, 9½ x 56 x 12'

Following page:
Mille Fiori with Gilded Sage
and Onyx Chandelier

2008

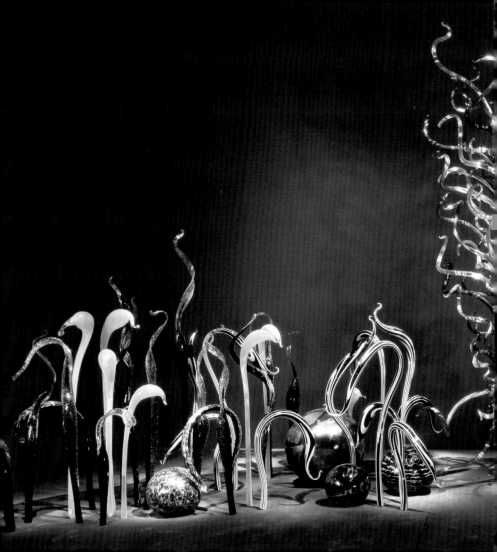

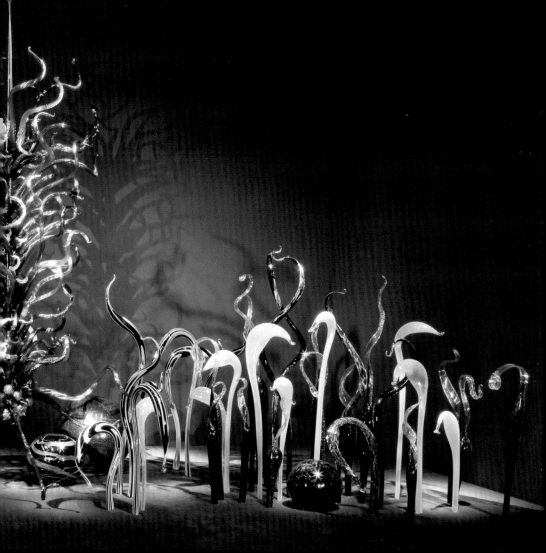

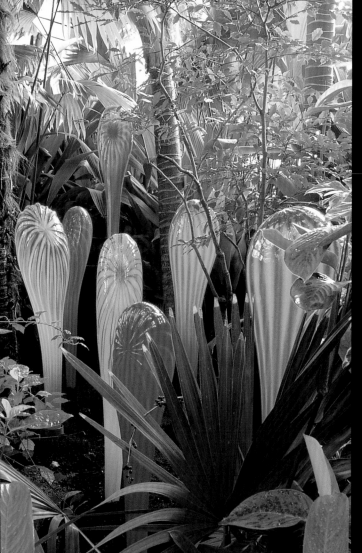

Tiger Lilies (detail)

Garfield Park Conservatory
Chicago, Illinois, 2001

Torchier

Franklin Park Conservatory
Columbus, Ohio
2009, 11 x 6'

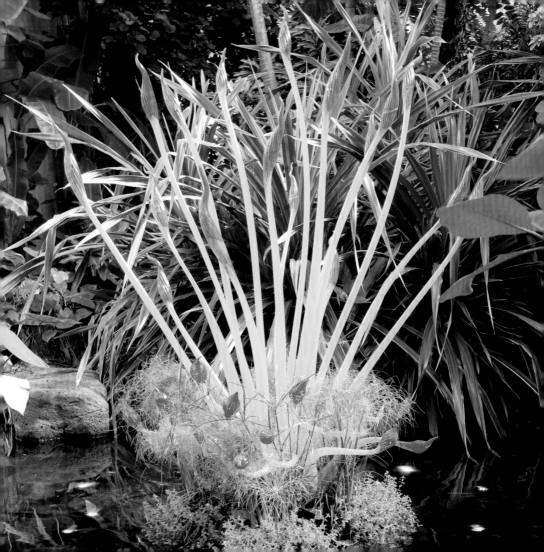

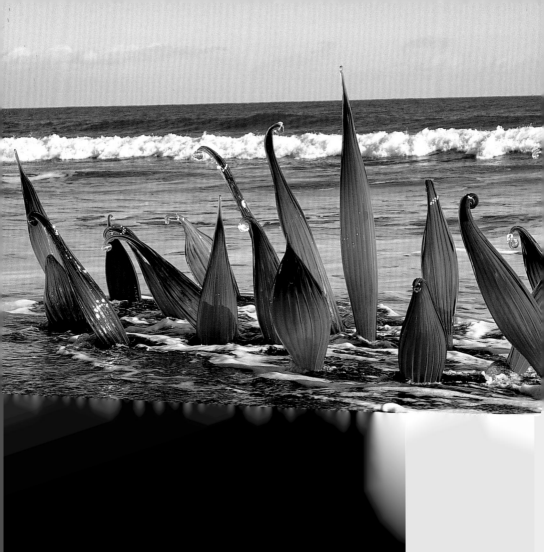

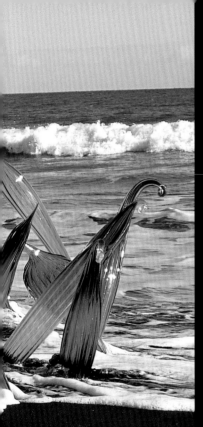

Green Ferns

Óseyrarsandur, Iceland
2000

Following pages:
Mille Fiori

2008, 9½ x 56 x 12'

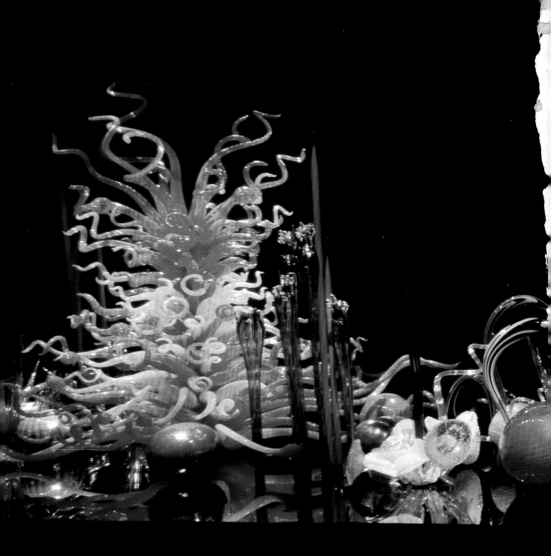

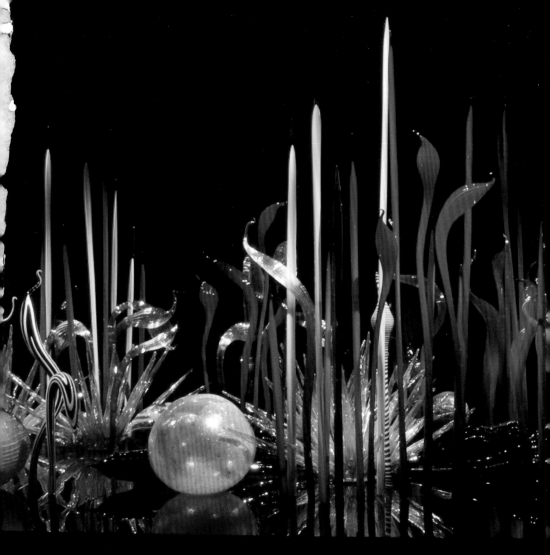

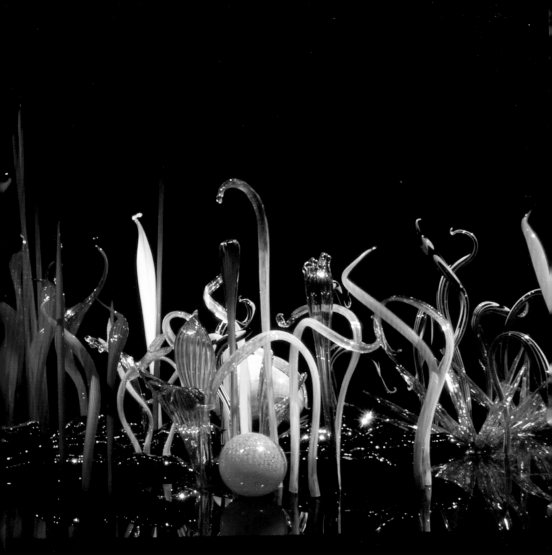

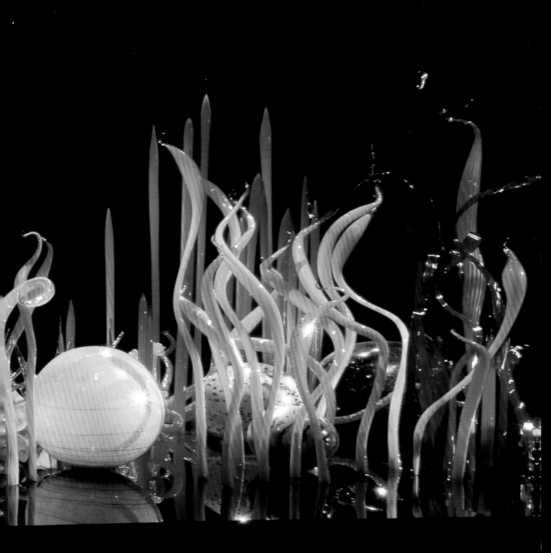

CHRONOLOGY

1941 Born September 20 in Tacoma, Washington, to George Chihuly and Viola Magnuson Chihuly.

1957 Older brother and only sibling, George, is killed in a Naval Air Force training accident in Pensacola, Florida.

1958 His father suffers a fatal heart attack at age 51. His mother goes to work to support Dale and herself.

1959 Graduates from high school in Tacoma. Enrolls in the College of Puget Sound (now the University of Puget Sound) in his hometown. Transfers to the University of Washington in Seattle to study interior design and architecture.

1961 Joins Delta Kappa Epsilon fraternity and becomes rush chairman. Learns to melt and fuse glass.

1962 Disillusioned with his studies, he leaves school and travels to Florence to study art. Discouraged by not being able to speak Italian, he leaves and travels to the Middle East.

1963 Works on a kibbutz in the Negev Desert. Returns to the University of Washington in the College of Arts and Sciences and studies under Hope Foote and Warren Hill. In a weaving class with Doris Brockway, he incorporates glass shards into woven tapestries.

1964 Returns to Europe, visits Leningrad, and makes the first of many trips to Ireland.

1965 Receives B.A. in Interior Design from the University of Washington. Experimenting on his own in his basement studio, Chihuly blows his first glass bubble by melting stained glass and using a metal pipe.

1966 Works as a commercial fisherman in Alaska to earn money for graduate school. Enters the University of Wisconsin at Madison, where he studies glassblowing under Harvey Littleton.

1967 Receives M.S. in Sculpture from the University of Wisconsin. Enrolls at the Rhode Island School of Design (RISD) in Providence, where he begins his exploration of environmental works using neon, argon, and blown glass. Awarded a Louis Comfort Tiffany Foundation Grant for work in glass. Italo Scanga, then on the faculty at Pennsylvania State University's Art Department, lectures at RISD, and the two begin a lifelong friendship.

1968 Receives M.F.A. in Ceramics from RISD. Awarded a Fulbright Fellowship, which enables him to travel and work in Europe. Becomes the first American glassblower to work in the Venini factory on the island of Murano. Returns to the United States and spends four consecutive summers teaching at Haystack Mountain School of Crafts in Deer Isle, Maine.

1969 Travels again throughout Europe and meets glass masters Erwin Eisch in Germany and Jaroslava Brychtová and Stanislav Libenský in Czechoslovakia. Returning to the United States, Chihuly establishes the glass program at RISD, where he teaches for the next fifteen years.

1970 Meets James Carpenter, a student in the RISD Illustration Department, and they begin a four-year collaboration.

1971 On the site of a tree farm owned by Seattle art patrons Anne Gould Hauberg and John Hauberg, the Pilchuck Glass School

experiment is started. Chihuly's first environmental installation at Pilchuck is created that summer. He resumes teaching at RISD and creates *20,000 Pounds of Ice and Neon*, *Glass Forest #1*, and *Glass Forest #2* with James Carpenter, installations that prefigure later environmental works by Chihuly.

1972 Continues to collaborate with Carpenter on large-scale architectural projects. They create *Rondel Door* and *Cast Glass Door* at Pilchuck. Back in Providence, they create *Dry Ice, Bent Glass and Neon*, a conceptual breakthrough.

1974 Supported by a National Endowment for the Arts grant at Pilchuck, James Carpenter, a group of students, and he develop a technique for picking up glass thread drawings. In December at RISD, he completes his last collaborative project with Carpenter, *Corning Wall*.

1975 At RISD, begins series of *Navajo Blanket Cylinders*. Kate Elliott and, later, Flora C. Mace fabricate the complex thread drawings. He receives the first of two National Endowment for the Arts Individual Artist grants. Artist-in-residence with Seaver Leslie at Artpark, on the Niagara Gorge, in New York State. Begins *Irish Cylinders* and *Ulysses Cylinders* with Leslie and Mace.

1976 An automobile accident in England leaves him, after weeks in the hospital and 256 stitches in his face, without sight in his left eye and with permanent damage to his right ankle and foot. After recuperating he returns to Providence to serve as head of the Department of Sculpture and the Program in Glass at RISD.

Henry Geldzahler, curator of contemporary art at the Metropolitan Museum of Art in New York, acquires three *Navajo Blanket Cylinders* for the museum's collection. This is a turning point in Chihuly's career, and a friendship between artist and curator commences.

1977 Inspired by Northwest Coast Indian baskets he sees at the Washington State Historical Society in Tacoma, begins the *Basket* series at Pilchuck over the summer, with Benjamin Moore as his gaffer. Continues his bicoastal teaching assignments, dividing his time between Rhode Island and the Pacific Northwest.

1978 Meets William Morris, a student at Pilchuck Glass School, and the two begin a close, eight-year working relationship. A solo show curated by Michael W. Monroe at the Renwick Gallery, Smithsonian Institution, in Washington, D.C., is another career milestone.

1979 Dislocates his shoulder in a bodysurfing accident and relinquishes the gaffer position for good. William Morris becomes his chief gaffer for the next several years. Chihuly begins to make drawings as a way to communicate his designs.

1980 Resigns his teaching position at RISD. He returns there periodically during the 1980s as artist-in-residence. Begins *Seaform* series at Pilchuck in the summer and later, back in Providence, returns to architectural installations with the creation of windows for the Shaare Emeth Synagogue in St. Louis, Missouri.

1981 Begins *Macchia* series.

1982	First major catalog is published: *Chihuly Glass*, designed by RISD colleague and friend Malcolm Grear.
1983	Returns to the Pacific Northwest after sixteen years on the East Coast. Works at Pilchuck in the fall and winter, further developing the *Macchia* series with William Morris as chief gaffer.
1984	Begins work on the *Soft Cylinder* series, with Flora C. Mace and Joey Kirkpatrick executing the glass drawings.
1985	Begins working hot glass on a larger scale and creates several site-specific installations.
1986	Begins *Persian* series with Martin Blank as gaffer, assisted by Robbie Miller. With the opening of *Objets de Verre* at the Musée des Arts Décoratifs, Palais du Louvre, in Paris, he becomes one of only four American artists to have had a one-person exhibition at the Louvre.
1987	Establishes his first hotshop in the Van de Kamp Building near Lake Union, Seattle. Begins association with artist Parks Anderson. Marries playwright Sylvia Peto.
1988	Inspired by a private collection of Italian Art Deco glass, Chihuly begins *Venetian* series. Working from Chihuly's drawings, Lino Tagliapietra serves as gaffer.
1989	With Italian glass masters Lino Tagliapietra, Pino Signoretto, and a team of glassblowers at Pilchuck Glass School, begins *Putti* series. Working with Tagliapietra, Chihuly creates *Ikebana* series, inspired by his travels to Japan and exposure to ikebana masters.

1990 Purchases the historic Pocock Building located on Lake Union, realizing his dream of being on the water in Seattle. Renovates the building and names it The Boathouse, for use as a studio, hotshop, and archives. Travels to Japan.

1991 Begins *Niijima Float* series with Richard Royal as gaffer, creating some of the largest pieces of glass ever blown by hand. Completes a number of architectural installations. He and Sylvia Peto divorce.

1992 Begins *Chandelier* series with a hanging sculpture at the Seattle Art Museum. Designs sets for Seattle Opera production of Debussy's *Pelléas et Mélisande*.

1993 Begins *Piccolo Venetian* series with Lino Tagliapietra. Creates *100,000 Pounds of Ice and Neon*, a temporary installation in the Tacoma Dome, Tacoma, Washington.

1994 Creates five installations for Tacoma's Union Station Federal Courthouse. Hilltop Artists in Residence, a glassblowing program for at-risk youths in Tacoma, Washington, is created by friend Kathy Kaperick. Within two years the program partners with Tacoma Public Schools, and Chihuly remains a strong role model and adviser.

1995 *Chihuly Over Venice* begins with a glassblowing session in Nuutajärvi, Finland, and a subsequent blow at the Waterford Crystal factory, Ireland.

1996 *Chihuly Over Venice* continues with a blow in Monterrey, Mexico, and culminates with the installation of fourteen

Chandeliers at various sites in Venice. Creates his first permanent outdoor installation, *Icicle Creek Chandelier*.

1997 Continues and expands series of experimental plastics he calls "Polyvitro." *Chihuly* is designed by Massimo Vignelli and copublished by Harry N. Abrams, Inc., New York, and Portland Press, Seattle. A permanent installation of Chihuly's work opens at the Hakone Glass Forest, Ukai Museum, in Hakone, Japan.

1998 Chihuly is invited to Sydney, Australia, with his team to participate in the Sydney Arts Festival. A son, Jackson Viola Chihuly, is born February 12 to Dale Chihuly and Leslie Jackson. Creates architectural installations for Benaroya Hall, Seattle; Bellagio, Las Vegas; and Atlantis, the Bahamas.

1999 Begins *Jerusalem Cylinder* series with gaffer James Mongrain in concert with Flora C. Mace and Joey Kirkpatrick. Mounts his most challenging exhibition: *Chihuly in the Light of Jerusalem 2000*, at the Tower of David Museum of the History of Jerusalem. Outside the museum he creates a sixty-foot wall from twenty-four massive blocks of ice shipped from Alaska.

2000 Creates *La Tour de Lumière* sculpture as part of the exhibition *Contemporary American Sculpture* in Monte Carlo. Marlborough gallery represents Chihuly. More than a million visitors enter the Tower of David Museum to see *Chihuly in the Light of Jerusalem 2000*, breaking the world attendance record for a temporary exhibition during 1999–2000.

2001 *Chihuly at the V&A* opens at the Victoria and Albert

Museum in London. Exhibits at Marlborough Gallery, New York and London. Groups a series of *Chandeliers* for the first time to create an installation for the Mayo Clinic in Rochester, Minnesota. Artist Italo Scanga dies, friend and mentor for over three decades. Presents his first major glasshouse exhibition, *Chihuly in the Park: A Garden of Glass*, at the Garfield Park Conservatory, Chicago.

2002 Creates installations for the Salt Lake 2002 Olympic Winter Games. The *Chihuly Bridge of Glass*, conceived by Chihuly and designed in collaboration with Arthur Andersson of Andersson·Wise Architects, is dedicated in Tacoma, Washington.

2003 Begins the *Fiori* series with gaffer Joey DeCamp for the opening exhibition at the Tacoma Art Museum's new building. TAM designs a permanent installation for its collection of his works. *Chihuly at the Conservatory* opens at the Franklin Park Conservatory, Columbus, Ohio.

2004 Creates new forms in his *Fiori* series for an exhibition at Marlborough Gallery, New York. The Orlando Museum of Art and the Museum of Fine Arts, St. Petersburg, Florida, become the first museums to collaborate and present simultaneous major exhibitions of his work. Presents a glasshouse exhibition at Atlanta Botanical Garden.

2005 Marries Leslie Jackson. Mounts a major garden exhibition at the Royal Botanic Gardens, Kew, outside London. Shows at Marlborough Monaco and Marlborough London. Exhibits at the Fairchild Tropical Botanic Garden, Coral Gables, Florida.

2006 Mother, Viola, dies at the age of ninety-eight in Tacoma, Washington. Begins *Black* series with a *Cylinder* blow. Presents glasshouse exhibitions at the Missouri Botanical Garden and the New York Botanical Garden. *Chihuly in Tacoma*—hotshop sessions at the Museum of Glass—reunites Chihuly and glassblowers from important periods in his artistic development. The film *Chihuly in the Hotshop* documents this event.

2007 Exhibits at the Phipps Conservatory and Botanical Gardens, Pittsburgh. Creates stage sets for the Seattle Symphony's production of Béla Bartók's opera *Bluebeard's Castle*.

2008 Presents his most ambitious exhibition to date at the de Young Museum, San Francisco. Returns to his alma mater with an exhibition at the RISD Museum of Art. Exhibits at the Desert Botanical Garden in Phoenix.

2009 Begins *Silvered* series. Mounts a garden exhibition at the Franklin Park Conservatory, Columbus, Ohio. Participates in the 53rd Venice Biennale with a *Mille Fiori* installation. Creates largest commission with multiple installations on the island resort of Sentosa, Singapore.

COLOPHON

This second printing of **CHIHULY MILLE FIORI** is limited to 5,000 casebound copies. ©2012 Chihuly Workshop, formerly Portland Press. All rights reserved. DVD is for private home viewing only.

Photography

Parks Anderson, Ricardo Barros, Theresa Batty, Christian Baur, Jan Cook, Jack Crane, David Emery, Paul Fisher, Ira Garber, Russell Johnson, Scott M. Leen, Tom Lind, Teresa Nouri Rishel, Terry Rishel, William T. Schuck, Mark Wexler

Designers

Ann Enomoto & Janná Giles

DVD Director

Peter West

Typeface

Frutiger

Printed and bound in China by Hing Yip Printing Co., Ltd.

CHIHULY™
WORKSHOP

Post Office Box 70856
Seattle, Washington 98127
800 574 7272
chihulyworkshop.com
ISBN: 978-1-57684-176-1

Front cover:
Mille Fiori XV
2004, 5½ x 8 x 8'

Pages 16–17:
Red Finnish Boat
Nuutajärvi, Finland
2002, 19 x 8'